PASTELS

BY LESLIE B. DE MILLE

Walter Foster Publishing, Inc.
23062 La Cadena Dr., Laguna Hills, CA 92653

CONTENTS

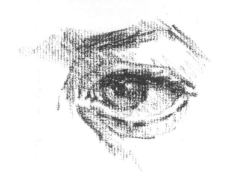

DEMONSTRATIONS

Dedicated to my wife, Isobel, who was behind me all the way — pushing. Many thanks to Walter Foster, Founder; and Lyle Foster, Publisher, whose support and faith have made these books a reality.

INTRODUCTION

PASTELS—a name that, in itself, implies soft, delicate pastel shades of color. Pastels are also sometimes confused with, (and even called) "chalk", which really 'grinds' me. Chalk, of course, is the hard, usually white, sticks that are primarily used for blackboards, quite unsuitable for fine art drawings or paintings. The word "PASTEL" comes from the *paste* made of pure, powdered color pigment, bound together with resin or gum, and molded into the sticks that we commonly know.

Pastels were first used as a painting medium in the 18th century. Rosalba Carriera (1674-1757), whose elegant portraits were popular with Louis XIV; followed by Quenton de la Tour, Watteau, and some 2500 other pastellists, insured pastels as a viable art form by 1780. The medium was carried far beyond the earlier methods by Edgar Degas and many others, continuing into this century.

More recently, pastels have been used by many professional painters, but only in a temporary or sketchy way. There have not been very many who have carried it to its fullest art form until recent years. There has been a great resurgence in the art of pastel painting, and people have been searching for more information on the 'proper' use of this fascinating medium. I trust that I can impart what knowledge I have to you. The practical and specific uses that are employed, I can explain to you; however, you must supply the artistic quality and verve, just as in any other form of painting.

In addition to using the techniques and applications I show in this book, study the works of de la Tour, Chardin, Degas, Wm. Merritt Chase, and others. Study not only the technical or mechanical knowledge, but the feeling, seeing, and interpretation—it takes more than just reading books. Your abilities will improve by doing, throwing away, and doing again. This is how you develop your talent. I am a firm believer in being BORN with talent. I also believe in studying and developing that talent by hard work. There is nothing more pathetic than to see a talent that is wasted on someone who feels they have nothing more to learn.

WHY 'PAINTING' IN PASTELS?

I want you to feel like you are painting while using the pastels because that is exactly what you are doing. The difference is that you are mixing your colors directly on the surface, rather than on a palette. There is no pre-mixing to do. You can be bold, aggressive and strong with your approach, or delicate and gentle for 'glazing' and pulling together—but not fragile and pasty in color! You are actually painting while utilizing your drawing—building layers of color and values, etc. You can paint on almost any surface that has enough tooth to hold the pastel color.

In this book, I will show you three of my favorite surfaces to use. You will see that I use velour paper in the demonstrations more than the others. I have two reasons for this. First, I started doing pastels on velour many years ago and have a special affinity for it. I feel that I have become quite proficient with it. The second reason is that I have been offended by a statement in a previously published book that says "velour is an abomination". This, of course, is completely untrue and shows the author's lack of knowledge and/or ability.

I will be working with soft pastels in this book. There are hard pastels and oil pastels but I am not referring to them. I have nothing, at all, against these types of pastels, but am only involved with the application of soft pastels since this is what I use. You will find that they vary in softness, depending on which pigments are used that are necessary to produce the certain color. Some colors will be extremely hard textured, in this case you should try similar colors in a different brand. They tend to vary in softness from one manufacturer to another. You will probably find, as I have, that rich reds and violets, etc. are the most common culprits.

On page 5 are actual photos of my pastel equipment. My large tray that I use in my studio measures about 32" x 56" and holds almost all the pastels and colors that I might ever need. I also have favorite colors that are stored away, in quantity, in case they become impossible to buy. This was a good lesson to learn, years ago, when a particular manufacturer of pastels not only omitted many of their colors, but also changed the formula for their whole line; thus, depriving pastellists of some of the best colors and textures that were available. I wish someone had allerted me earlier. I would pay ten times the price if two or three of those colors were available now. Anyway, I'm telling you this so you, too, can 'hoard' your favorites.

MATERIALS

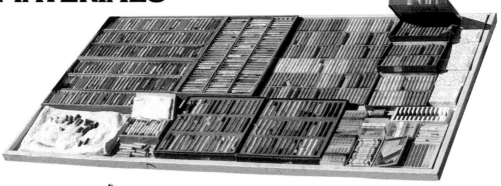

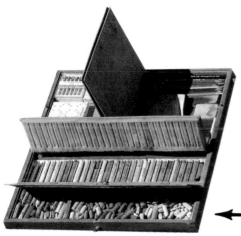

This is my portable tray that I take with me for demonstrating or painting away from my studio. It holds the used pastels in the front tray, whole sticks in the second tray, and there are two additional compartments for 'whatever'. This tray is part of a custom-made easel designed to hold pastels, oil paints, brushes, turps, linseed oil, palette, and almost the kitchen sink. It can hold a 16" x 20" palette and canvas inside while folded, and will extend for me to either sit or stand, allowing work on anything up to 44" high and any practical width.

The clipboard shown is 24" x 30" and is one of several various sized boards that I keep on hand (up to 36" x 48"). The boards are covered with several sheets of plain paper (at least 10). You may be able to obtain paper like this from one of your local printers in a size that would be useful to you, and for a fair price—but please don't tell them I sent you! I fasten the sheets to the board with a staple gun. The layers of paper form a pad to work over. I find it better to have the 'give' underneath than to work directly over the board, you might pick up the grain of the board without it. The clip at the top can be purchased from a stationery or office supply store. Be sure to buy one large enough to hold your drawing securely.

I have included photos of the pastel and Conte sticks just for identification. There are many different pastel manufacturers and I have supplies from most of them. YOU will have to choose your own favorites.

APPLICATION

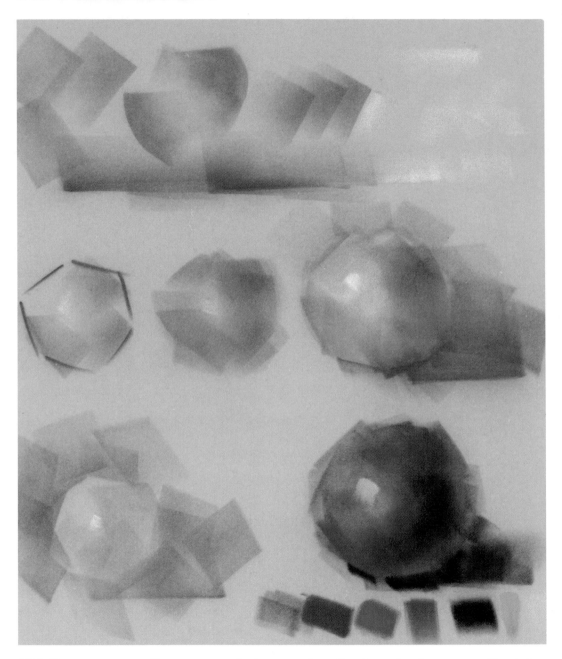

This illustrates several important techniques and applications that form a good basis in the use of pastels. I used Conte crayon with flat strokes, then, using more pressure, make a sharp edge on one side, blending to nothing on the other. Do the same with white pastel and other colors. Make shapes with stroke style rather than trying to draw perfect circles; create images with just form, no lines. Add character with light, background, and shadows. Note how the shadow makes it "sit down". Try negative space for form. Note the use of red tone for a complement of blue-black. You should always try to use all of your primaries in your mixture, with one predominating hue (color).

PAPER

As stated earlier, I will only use three different painting surfaces for the demonstrations in this book. There are many other surfaces you can use, just be sure that they have enough 'tooth' to hold the pastel and to allow a good amount of layering on the surface before the pores fill up and make it too slick to hold any more color. The first example of forms is on velour paper (page 6). The second is Canson (Mi-Teintes), and the third is sandpaper. You may use canvas or other papers that are not made for pastels such as: watercolor, charcoal, rice or strathmore-type papers, but they are not the best choice for various reasons. There are, however, some very fine, imported, handmade papers that I find are excellent to use, but they are very expensive for experimenting and learning.

VELOUR will be used most often in the following demonstrations. You are free, of course, to substitute any surfaces you desire in any of these illustrations. I certainly encourage you to vary whenever you can. Be individual in your own creations. Velour offers a soft, subtle quality with each stroke — no blending with your finger or a stump, excellent for glazing of one color over another, crisp and fresh. You can be aggressive and add lots of strength too. It is good for young people's portraits and for animals (fur etc.). Many people get a 'fuzzy' look from overworking on the velour because they don't know when to leave it alone. Do not over-do. If you do overwork an area, try glazing with a large, flat color piece to eliminate detail. It's easy to do with pastels because by varying the pressure you can cover as much or as little as you want to get the desired effect, especially on velour.

FRONT

BACK

CANSON has a good surface for accepting pastels and comes in many colors from light to very dark. You can try the various tones, but I find that generally the lighter to mid-tone, softer tints are easier to work with. I also like to use the back (or wrong side) to avoid the quilt-like, pock-mark pattern of the front side which gives too much sameness to the surface. Try both sides and see for yourself. You may want to use the correct side for a specific effect. Note that I show both sides in this sample of Canson.

SANDPAPER has no direct pattern or grain so the effects you get with the first strokes are irregular until you build up with more application. It will hold a good amount of pigment (especially the coarser grained sandpapers), and after blending with your finger or stump it becomes easier to apply the strokes as you want them. Be careful when using your finger for blending on sandpaper!

BLENDING & LAYERING

VELOUR

1

2

B. Step 1 shows Conte light and dark sanguine on velour and Canson. Notice the difference in the strokes on the velour with no smudging, and the grain effect on Canson, with smudging on the lower part. You can see the immediate, soft to very dark, feeling on the velour, which does not show on the Canson as yet.

CANSON

1

2

D. Step 3 shows all of them with the same combination of colors: two Conte sanguines, white, warm red, gold ochre, light green, olive green, medium blue (that hardly shows), and a dark blue-grey. Notice how the green tones soften the darks, deepen the bright reds, and cool and soften the light tones.

SANDPAPER

1-2

A. These steps, and the finished samples on the next two pages, are to show you the different ways that each of the three papers react to the same application of color and technique. Do these swatches yourself on whatever pastel papers you have; follow the same sequence that I show you to better understand how the colors blend on each different surface.

3

C. The combined step 1 and 2 on sandpaper, also shows little blended quality in the sanguine areas, even though the lower portion has also been smudged with my finger. Step 2, velour, shows the addition of white and warm red, while the Canson has these, plus gold ochre and light green. The sandpaper, step 2, shows added white, warm red, and gold ochre. These colors are softer in pigment than the Conte; thus, you can see how the grain is filled in more on both Canson and sandpaper. The velour still holds the same texture with no blending. Notice that on all three papers, the blending is becoming easier because of the build-up of color pigment.

3

E. Now you see that all three papers have their own distinctive quality of texture and blending. In the more mixed areas, they all have a very beautiful blend of color and style while on the left side, the velour retains the soft, crisp areas that the others do not have until they are more advanced and filled in.

3

9

BLENDING & LAYERING . . . CONT'D

I finished these samples of color by going through the center, from one end to the other with white, to show the covering power when applied to each paper, even to showing up in the lightest tones. This is where Canson and sandpaper excel, by the added crispness and covering of lighter colors. The velour will do it, but not with the same "authority", especially if you have worked over an area more than once. By the way, this is a good lesson to remember. The cleaner and fresher you keep your painting, the better your results will be. Any area that is worked too much will not have the crisp, clean, translucent look that is indicative of good pastel painting.

ORANGE (Sandpaper)

Let's start applying some of the different techniques that I mentioned on page 6. Step 1 shows the basic shape, using Conte, with strokes rather than a circle. Notice the character in the orange already.

Step 2 — Application of the basic orange color. Because this is Canson, I have smudged part of it to show how it looks compared to where there is no smudging.

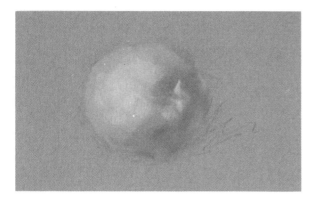

Step 3 — I am taking you through this first demonstration slowly so that you can follow closely. Here, I have added some cool green for shadow and some yellow for the light side. This gives the orange a third dimension at this stage.

When you set up your own still life, whether it is a simple orange or apple, a very elaborate subject, or when doing a portrait, try to give one main source of light so that you have a definite 'light' and 'shadow'. It makes it much easier to see when you do this. Of course, when you become very proficient with values, color and form, etc., you can try many different kinds of lighting. Remember, it isn't the edge or outline that gives the realistic look, it's the volume and form created by values and color. More on values and color on pages 14 and 15.

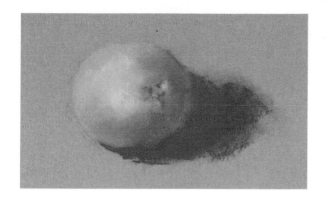

Step 4 — I have added a cool blue-grey shadow next to the orange. It is now 'sitting down' instead of 'floating' on the paper. I increased the shadow-green on the orange, and added more red-orange to the middle tone (the areas of transition between shadow and light).

Take note of the soft edges, and the pulling together in the dark areas so the orange merges with the shadow. To finish, see where I have added reflected light (green) into the shadow on the edge of the orange. A couple of sharp edges but still allowing the merged areas to remain in order to avoid the hard-edged or stiff look. DO NOT make the edges SOFT ALL OVER. You must have areas of lost and found. I created a background of green, with some soft pink, light color to complement the green (Remember to use all your primaries and keep one predominate). The finishing highlights are a blue-cast off-white, and add a few 'tweaks' to enhance the character and 'bumps'. Keep in mind the simplicity of form and values before adding detail.

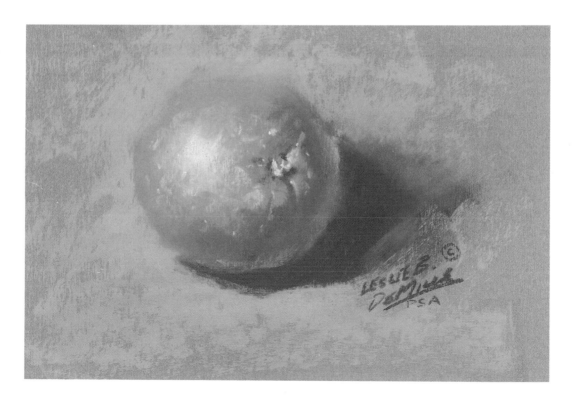

COLOR TEMPERATURE (Velour)

Color temperature is, perhaps, one of the more difficult things to see and project. Try to show the variations in the folds of the white cloth by using changes in color temperature rather than value changes. This is done on grey velour paper.

Sketch the folds very lightly with a light sanguine Conte. Add white and medium blue-grey in Step 2, to show the character of the folds. Add violet to the shadows, and then come out of the shadows with reds, orange, and pinks; working up to the lights of the folds with warm yellow.

Use green in the reflected lights. Note the soft transition from shadow to light on the folds against the sharp edge of the cast shadows (cast from the curves of the folds).

This is a good lesson to remember when confronted with showing roundness, for instance: a body, an arm, or the curve of an object, where there is not much value change to show these contours. Also, keep in mind, the natural shadows which show the curve, roundness, and soft transition from dark to light (or warm to cool) in a rounded object. Remember, cast shadows that are hard edged, cast from whatever protrusion it may be (a nose, hat, clothing, one grape over another . . .), can also show the curve, roundness, or shape of what they are casting onto.

In Step 4, you can see where I added more of the warm and cool colors and concentrated on the soft transition of the natural shadows of the folds. See how they merge and roll with the subtle value changes, as well as the color temperature changes.

Now, by glazing white over these many colors, using different pressures, you can give even more form and character to the folds, as well as subduing or softening any areas that have become too heavy with color. This is one of the wonderful things about pastels; you can glaze over, or at the same time add strength, just by the way you apply pressure. You can see where I also defined the cast shadows with the dark colors, and added more cool green tones to the reflected lights. These reflected lights will generally be sharp on one side and blend away on the other. You will notice this even more in the following examples.

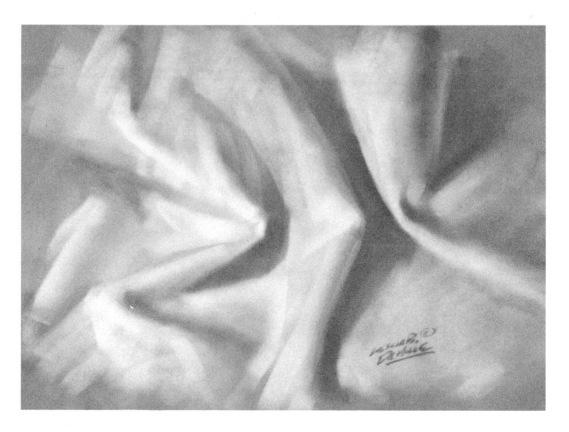

APPLE (Velour and Canson)

I chose these two papers of similar colors to show the different effects they cause while using identical pastel colors and the same approach. The velour-applied strokes are different from the Canson. Step 1 again shows the hexagon strokes, rather than a circle. Note on left side of the Canson (background), in Step 2, the area I smudged with my finger, as well as on the apple. The portion on the right side is not smudged at this point. On velour, do not smudge. It is very rare to smudge on velour because it is not necessary. I want to emphasize the two papers, not that one is better than the other, but as seen earlier (pages 6 thru 11), you do get different effects.

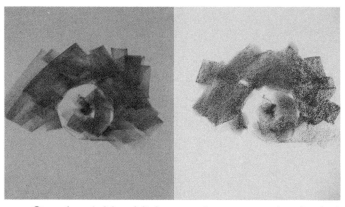

Step 1 — Sketch in. Step 2 — Apply olive green in the background and on the apple. Step 3 — Add orange base color to the apple, blue-white to cloth in front, and dark blue-grey for dark shadows. Then add warm yellow to the cloth to give color, plus light blue-grey, going into shadows and folds. Next, add white to the lighter areas to give light and forms to folds . . . Step 4 — Add reddish sanguine tone on the shaded side of the apple and rich bright yellow on the light side of the apple to bring out the light (thinking where the light is coming from). Doing an apple is no different than doing an eye, head, nose, ball, or grapefruit; you have to have a light side, turning into shadow, with reflected light turning into deepest shadows.

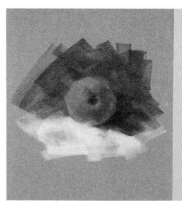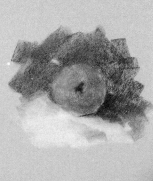

The reflected light is not as light as on the lighted side, so keep it back in value where it belongs, squint and see it fall back into place, subdued. Add light green tones between lights and background, then merge. Keep in mind that green will help turn things away from you;

therefore, on the light side of the apple (on the edge), see the soft green added to help turn that light side away (using color temperature instead of value).

Add pale, crisp highlight to apple, and white over the colors in the foreground to make the cloth brighter. The same kind of strokes were used on both papers for the

accents around the apple. Notice the strokes showing on the velour. They are there on the Canson but they're not as crisp and distinct, yet, the Canson does show its own beauty and quality, with some textured paper showing through that the velour doesn't have.

The velour has its own special textural effects. I put paper over half of each of the apples and sprayed well with fixative. Lifting back the paper (Step 7) shows what happened to the sprayed area on each paper. The color on the Canson seems to have deepened more than on the velour. Just an experiment to let you see what happens.

Later, I covered the other half and sprayed to make the whole thing come together and make the apples 'whole' again. This is a good indication of what happens after spraying (although I did spray these heavier than usual). The colors deepen. Look what happened to the highlight on the Canson apple. Look at the loss of some soft nuances of shading and light on both papers. I had to come back and re-establish my highlights (the apple needs that crisp highlight) and anything else that was obviously lost that I wanted back. Sometimes it's best not to spray at all, or spray very little, or spray from time to time as you progress.

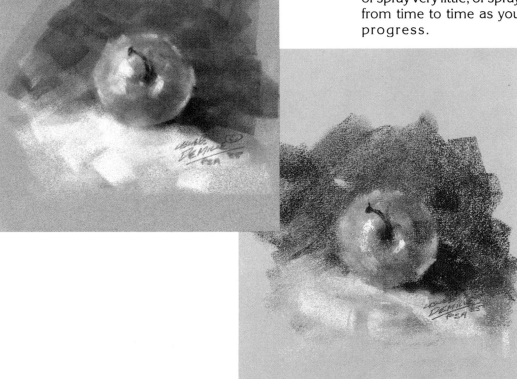

ROSES (Velour)

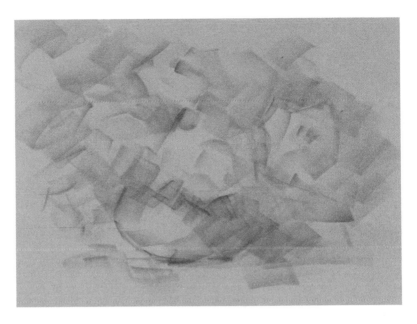

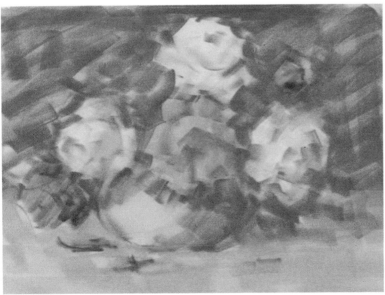

In the first step, I sketched in the impression of the bouquet and vase to indicate everything as a whole. Step 2 shows the various basic colors added to each area; dark red, pink, and yellow for the roses, plus ochre for the vase and foreground, and blue-grey for the background and drawing. Keep it simple!

In Step 3, add deeper colors for everything in the darker areas; reds and yellows in the roses, and green and gold ochre in the vase; remember to make each rose look *round* while retaining the overall look of the bunch. Notice the addition of various colors in the background to tie it all together. Step 4 — Now I have defined the petals with light colors as well as darks. The stems and leaves are loosely indicated, as are the few petals in the foreground. The background has also been given more color. When working on the petals of the roses, think of what I have said about more pressure on the front or back of a flat pastel piece to give a sharp edge on one side of the stroke, while blending away to nothing on the other. It works, doesn't it!?

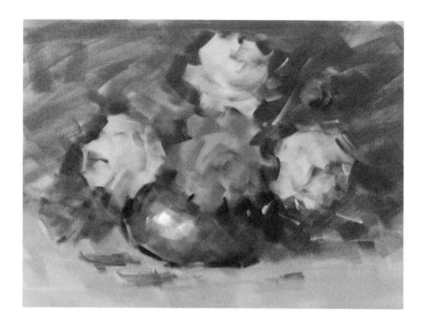

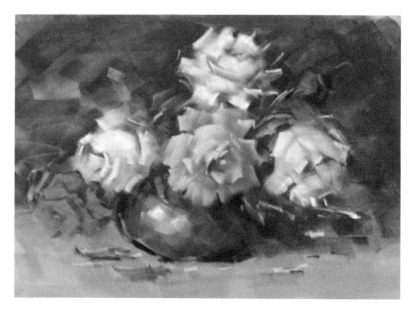

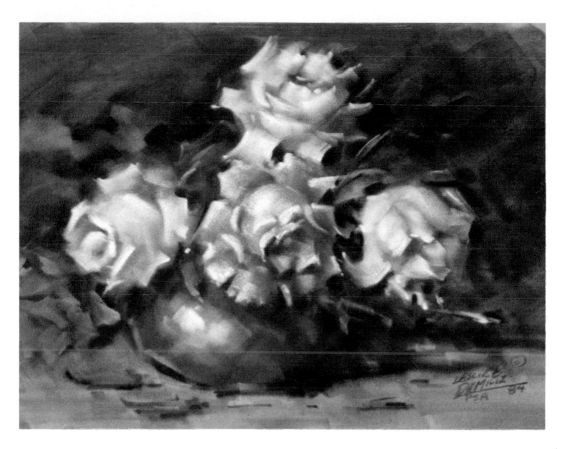

Think about the lost edges merging into the background. They give the feeling of coming out of the dark. Think about the found, or sharp, crisp edges on some of the petals to make them come forward more, and to give freshness to the painting. Take note, also, that the roses closest to the source of light have the lightest values. The finished painting shows more blue-grey darks in the background, and you can see where these strong darks are accenting different edges and forms. I finished with the lightest colors, not only in the strong lights, but also to soften and lighten whole areas; the pink roses for instance, especially in the middle.

GLASS (Sandpaper)

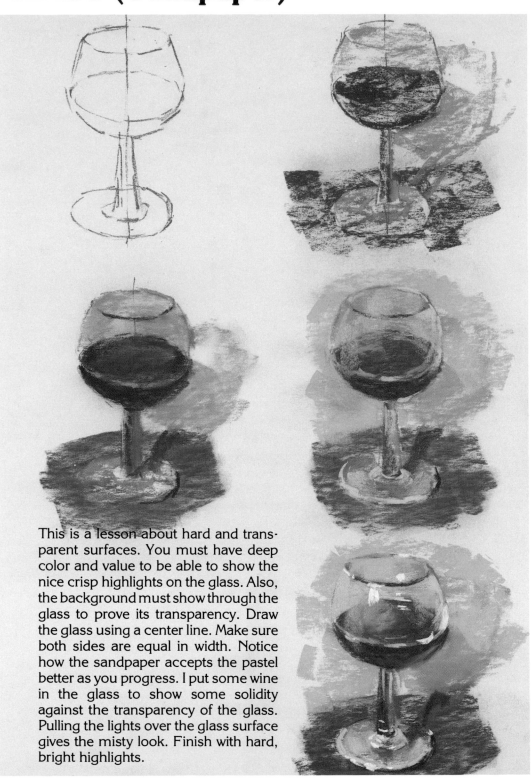

This is a lesson about hard and transparent surfaces. You must have deep color and value to be able to show the nice crisp highlights on the glass. Also, the background must show through the glass to prove its transparency. Draw the glass using a center line. Make sure both sides are equal in width. Notice how the sandpaper accepts the pastel better as you progress. I put some wine in the glass to show some solidity against the transparency of the glass. Pulling the lights over the glass surface gives the misty look. Finish with hard, bright highlights.

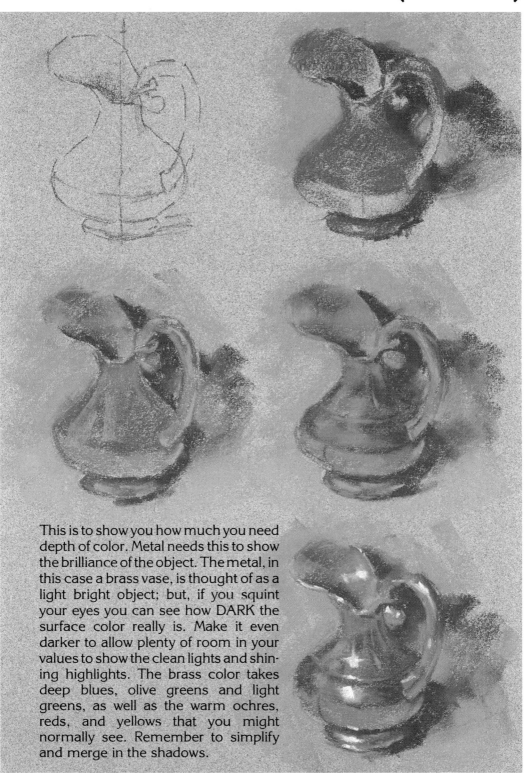

This is to show you how much you need depth of color. Metal needs this to show the brilliance of the object. The metal, in this case a brass vase, is thought of as a light bright object; but, if you squint your eyes you can see how DARK the surface color really is. Make it even darker to allow plenty of room in your values to show the clean lights and shining highlights. The brass color takes deep blues, olive greens and light greens, as well as the warm ochres, reds, and yellows that you might normally see. Remember to simplify and merge in the shadows.

ONION (Velour)

This is a famous Maui, or Kula onion, golden yellow-red color (Kula onions are not red, but you will need the red to give the "golden" look), with that 'squeaky' look all onions have. This is like doing a portrait, i.e. lots of strong character, with coloring the same as flesh tones. Although you don't have to worry about a likeness, you DO need to worry about getting the form, tone values, and color (cool and warm), as in a portrait.

Start with the loose, linear shape, as we did with the apple and orange, only now we have some character added. Step 2 — Add bright red and gold ochre on the onion, white with dark grey-blue and some green in the background and shadow, and through into the onion.

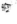

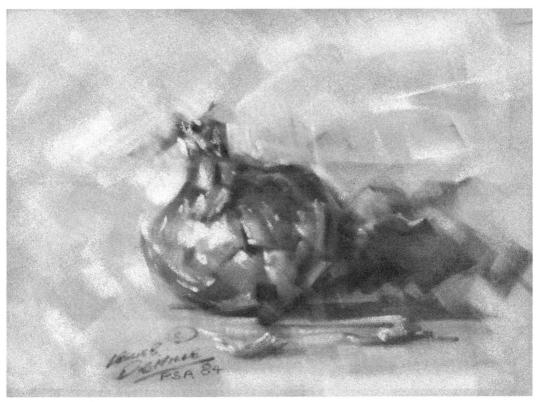

Step 3 — Accent the darks with deep reds and add more greens for the reflected lights. At this stage, you can see how much color is in the onion. When you get to the final step, you can glaze over this strength of color and soften or highlight as you want, BUT the color has to be there to begin with! Notice, in the finished onion, the lavender-pink next to some of the lights. This helps give the color of the onion, and comple-ments the red and the ochre. Punch in the highlights, keeping some zip in the strokes to provide the 'squeaky' look.

GRAPES (Velour)

Start very sketchy, showing mass of form rather than definite shapes. (By the way, I went to the market and personally selected the grapes for this still life, rather than looking at a photograph.) I don't think I've ever done a still life without having a 'live' setup.

Be sure there is a good, strong source of light, so you can see definite light, shadow, and form. In Step 2, add some accents to define a few areas of shadow and grape shapes. Add color: red for dark grapes; green, orange and ochre for light grapes.

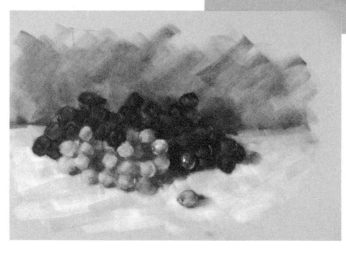

Add some yellows, reds and blues to the white cloth; and the same, plus greens, to the background. Use blue-grey for shadows and some definition. Keep in mind the general form of the whole bunch. At this stage everything looks quite dark, but you can build and model on these darks, up towards the lights.

When doing still life, after you have the general tones and colors all over, finish the perishable objects first, then if the fruit deteriorates, you can carry on with the rest of the objects. Step 4 — Add lights to the grapes, NOT HIGHLIGHTS, but the LIGHTER VALUES that give form and color. Note the one red and one green grape finished with accents of dark and light. See how the cool blue highlight on the warm red grape, and the warm pink highlight on the cool green grape, complement each other.

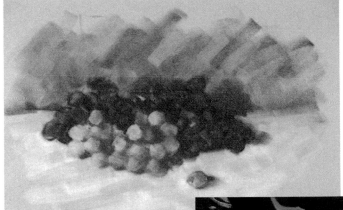

Add accents to darks and lights to define some grapes, but let most of them merge. Your imagination will form the rest of them.

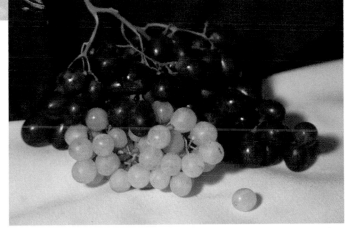

In the final painting, the grapes are different values and intensities of color, even the highlights are varied this way so they are not static. Note the addition of the stems with varying color. Put them mostly in the shadow areas of the grapes as this is where they seem to appear most often.

Compare the finished painting with the photo of my setup. This photo was taken to show you how it looked to me in the studio. You don't have to follow it exactly, try to be more artistic with what you are looking at. Remember, always use a live setup!

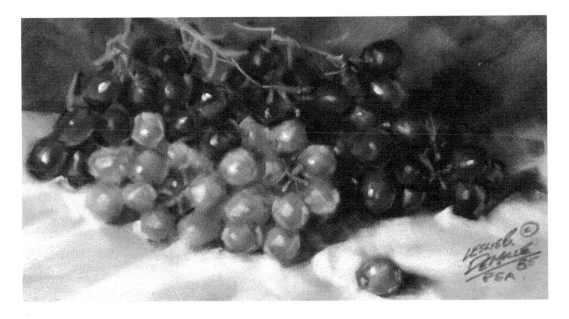

POINSETTIA (Velour)

Here, I used another live setup. Again, compare the photo with the actual rendering. Don't try to make a literal translation of the actual pot of flowers, make it YOUR particular interpretation. Block in loosely with shadow areas only, using half of a Conte crayon. Step 2 — Add the white background, coming up against the pattern of flowers and greens. Add general greens to leaves, and reds to flowers. Cover the paper.

Step 3 — Add some cool lavender tones to the shadows in the background. Add more red to the flowers, keeping loose and impressionistic. Poinsettias have a dancing, dazzling quality, so keep it fresh-looking. Add dark red for deeper tones where the petals go into the shadows.

Many of the pastel reds are hard in texture, especially the darker, rich reds, so if you can apply these strong and deep first, you can always lighten with softer, easier-to-use, brighter red tones. Add lighter greens to the leaves, almost finishing them. They are of secondary importance to this painting. I added maroon to the upper right of the poinsettias to show you the extra depth that is needed (on all petals) to throw the reds out lighter,

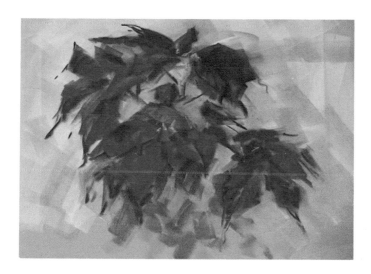

and also to merge edges into the background or leaves. Examine the photograph and the finished painting on the next page to see where some of the edges disappear into the shadows. The maroon also retains the rich colors, with separation by shadowing, and adding more depth around the tones, rather than adding paler, weaker colors to the reds. I want to repeat what I said about using photos. It is always better to use a 'live' set-up for your paintings, no matter what it may be. Only after you have done hundreds of paintings from life can you feel comfortable in being able to interpret successfully from photographs. The key word is 'interpret', because that is the main use of a photo NOT TO COPY IT. I feel very strongly about this, and if you have doubts about it, look at all the stiff, ugly copies of photos that you see, not only by amateurs, but by so-called professionals in some very fine galleries. The photo of the poinsettias was taken AFTER I had completed the painting. It was taken from the view that I had of my studio set-up. I had a cloth draped close behind the flowers to get the pattern created from the play of light, to add more interest to the background.

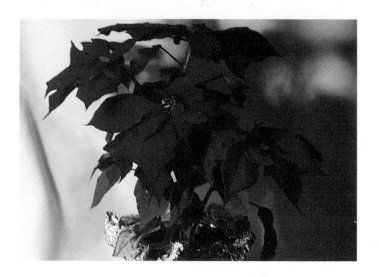

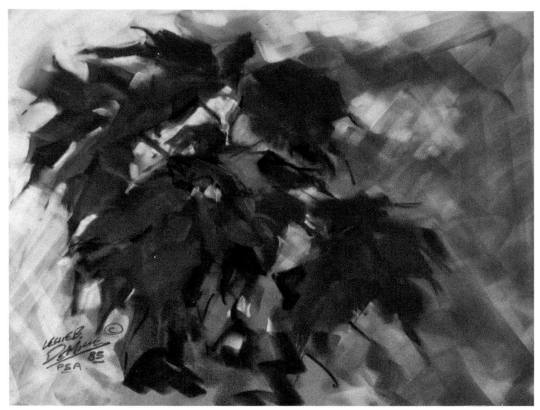

Now finish with more depth and accents around the leaves and pointsettias by intensifying the shadows. Accent here and there to bring out some of the leaves and petals; letting others merge into the background and shadows. Cut in and out with white around some edges to add crispness. Finish with a lighter, cleaner red on the petals to throw out the values on some of them, where needed, to show where the play of light is coming from. Use more white in the background the same way.

BLUE CANYON (Velour)

This is to show how you can create a scene with very little drawing and detail to be concerned about. I have kept it simple by using only pale blue, medium blue, dark blue-grey, and a pink tone to complement the blues. With a little imagination, I came up with a simple design that actually makes a beautiful canyon painting. You can use this same idea for many different kinds of scenes and color schemes.

SUNSET (Velour)

I painted this from our condo on Maui. I have done several paintings of sunsets from this same area. I want to show you how to take a sunset from almost anywhere and add your own personal touch to it by putting in a foreground of your choice.

After laying in the basic areas with Conte crayon, I proceeded with the cool tones of the sky and water, very subtly showing the horizon line at the same time; then adding the blue-grey for the water and building. Over this, I added bright red—softly in some areas, very strong in others.

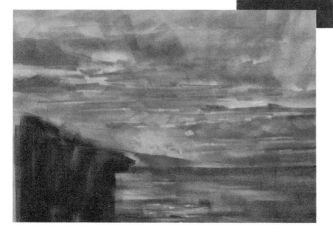

In Step 3, I added orange and yellow to give brilliance to the sky, concentrating on the area closest to the sun. Notice that I also put these colors in the water for added color and reflection.

Keep enough color around the setting sun, so that when the actual light is put in the sun itself, it will stand out. Make sure there are enough contrasts of complementary colors throughout the sky to give a luminous effect.

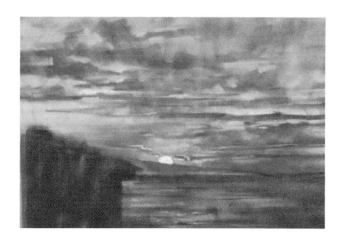

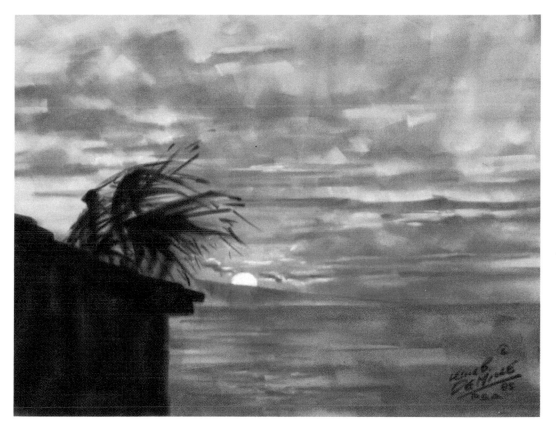

The luminous effect will show the beauty of a clean, sunlit sky. Paint the sun with the strongest light you have. Then, add the foreground of your choice in deep rich blues, purples, or blacks. In this case, as I said, the scene is outside our condominium looking from Kaanapali shoreline to the island of Lanai where the sun was setting.

RED ROCK (Canson)

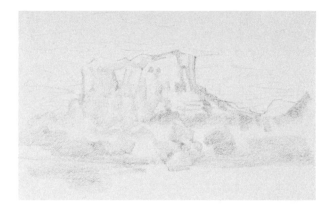

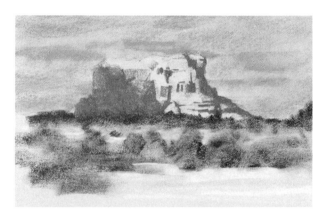

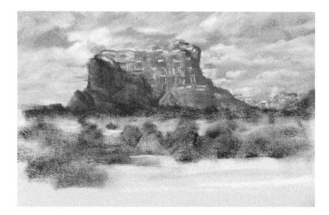

This is Courthouse Butte, the view looking out my studio window from where we now live in Arizona. First sketch the pattern of the mountain, sky, and trees. Cover the paper with the local color of trees, mountain, and sky, leaving areas for clouds later. I started to indicate on the left, Step 2, the special red rock look to the mountains here in the Sedona area, keeping it as simplified as possible. In Step 3, add more red tones to the rock (enough to work over with lighter tones and colors later).

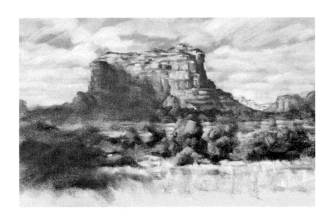

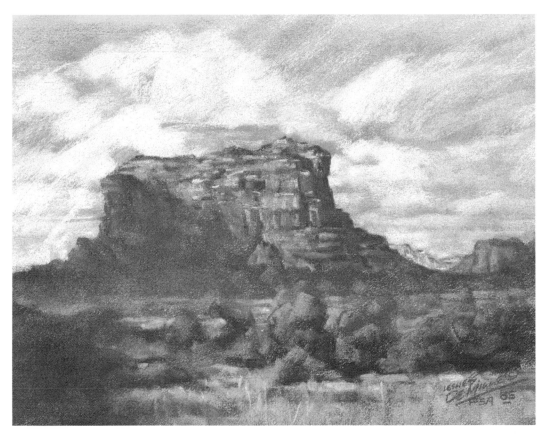

Add some grey colors and whites to indicate clouds (not just pure white, use all colors to create the whiteness). Note the left side of the mountains where it gets darker. Keep the sky impressionistic. Keep the greens of the foreground subdued, not too bright. It is difficult to paint the bright blue sky, the bright red rocks, and the bright green foliage and make it come off as beautiful and spectacular as it really is. By subduing the greens, you can get away with the other colors. In the final touches, add a few lights here and there to sparkle it up.

ASPENS (Velour)

On the way back from teaching a class in Colorado, we drove by areas of fantastic, colorful aspen groves. The thing that made them stand out even MORE beautiful was the contrast of the bright orange and yellow aspens against the dark, rich blues and greens of the evergreens that surrounded them. After sketching the composition, proceed to Step 2.

Lay in some blue sky area, blocked in very simply. Apply dark greens to the pattern of darks and shadows. Add more blue sky, with white clouds running through the tree areas. Use oranges and yellows for the light on the aspens.

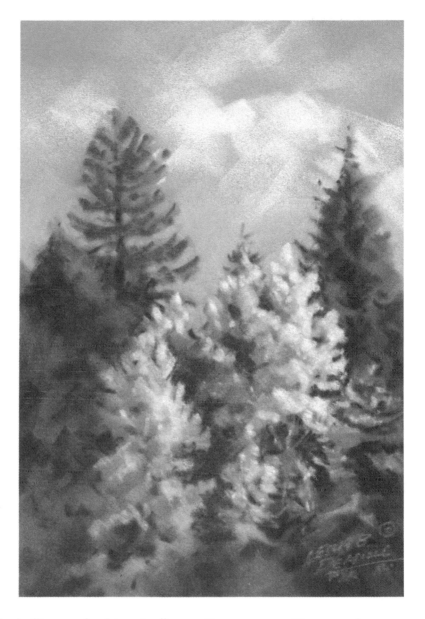

Remember to show the brilliance of gold and yellow on the aspens and the complementary colors surrounding them. There must be darks, so add very dark grey-blue to the original dark greens, working up from the established darks to 'pop out' the lights with some sharp, strong edges of dark, while still leaving some merging transitions. Add lighter greens to the evergreens and darker tones to the shadows of the aspens. These are two entirely different areas. The shadows on the aspens are NOT as dark as the lights on the evergreens. Squint your eyes to bring your values into better focus.

When you are driving and you see something that is irresistable, stop and make quick color sketches and notes so you have something for reference when you get to your studio.

EYE & WRINKLES (Velour)

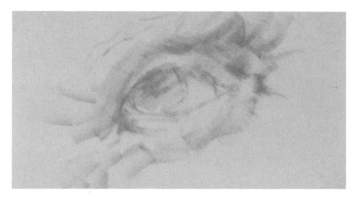

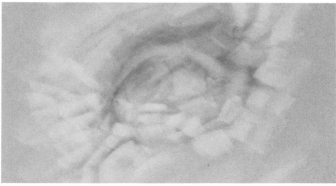

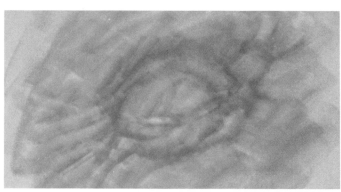

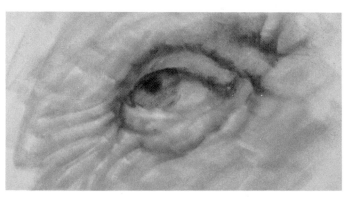

This eye is an enlarged version, done separately, from the portrait study of 'Eiler' on page 40. I chose this particular eye because of the glint and the wrinkled appearance. Sketch the basic form first. (Notice the indication of an angular shape in the eye, rather than round.) Next, Step 2 shows a pale yellow ochre to indicate the highlights. Spread it all over as a base for the flesh tone. Step 3 — Blush over everything with the lightest Conte sanguine, giving a warm, flesh-like color. This is not enough color, however, so add more warm red, especially around the eye and in the shadows. The eye area has a lot of warmth, the red in the shadows helps when putting in the cool tones, providing the needed complementaries. Step 4 shows the addition of a medium green, gold ochre (which gives the red more of a flesh color), and some dark blue-grey into the pupil and darkest shadow areas. In Step 5 add more green to the flesh tones, and the iris (also, notice the touch of blue in the white of the eye). Apply some pink tones, making sure there is enough color throughout to actually model the wrinkles by adding light tones, instead of dark lines to show the wrinkles. They then become a form, with 'hills' and 'valleys' instead of looking like gouges. The deep shadow has to show up under the upper lid, throwing out

the lids while setting the eyeball back, into the socket. The eye is a ball and must have the appearance of roundness in the socket; so, the transition from light to dark has to show, not only on the eyeball, but, also on the surrounding areas of the eye itself. Remember, the eye takes up a large area, not just the inner part. The catch-lights in the eye add to the 'liquid' look. The wrinkles are forms, just like the orange you did earlier (also, like the folds in the material on page 15). They each have a shadow side that merges with the middle tones up to the lights, with the warms and cools added, and then the highlights of varying degrees.

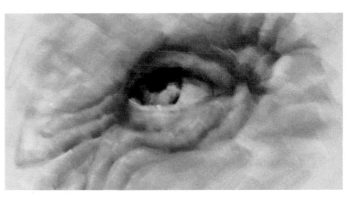

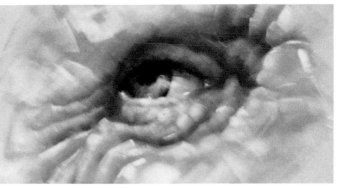

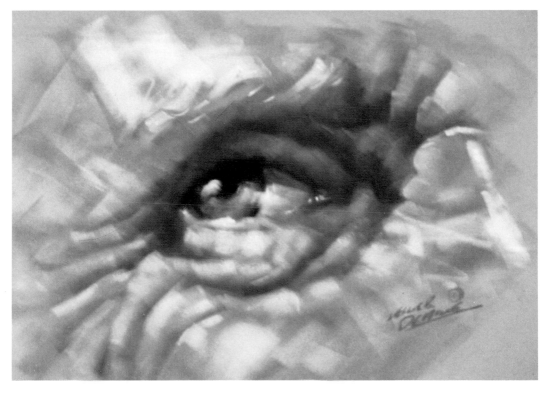

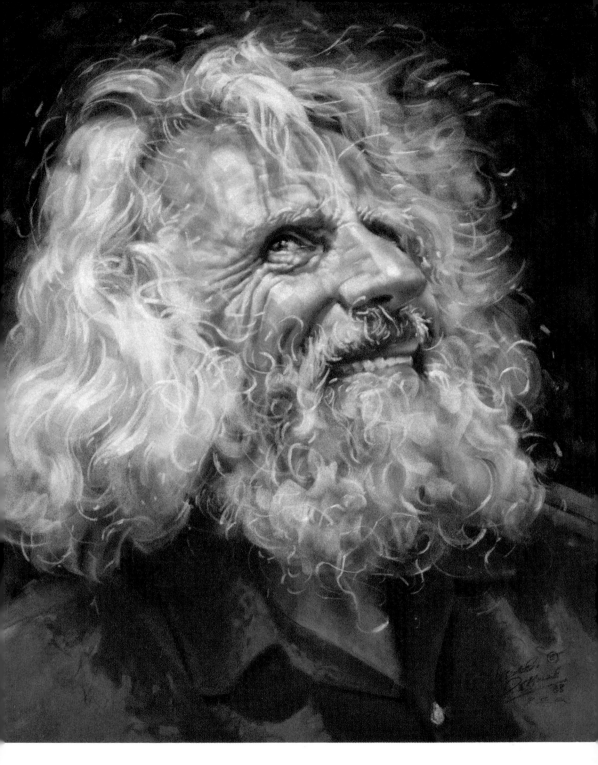

Eiler Larson modeled for years in Laguna Beach, California. What a fascinating face he had! The twinkle in his eye was the best. This is a pastel I did, now in print, that really shows his bombastic character. If I had tried to put in all the soft, wispy strands of hair, it would have looked terrible. Remember, masses of VALUE and FORM just SUGGEST-ING the detail and character, in this case, just 'tweaks' of hair.

INDIAN BOY (Sandpaper)

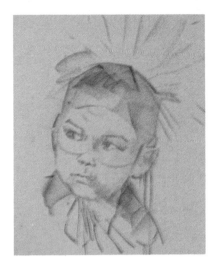

Since the face is the most important area, the clothing and headdress are done loosely and more impressionistic to keep the attention on the face. On sandpaper, the first layer of color needs to be smudged and worked into the grain so that the subsequent applications will be smoother looking, and the strokes can be left to give a more artistic feeling.

When the sandpaper becomes overloaded, the pastel goes on very slick and buttery, which can be bad, or, it can be an advantage that gives a nice effect that you can't get on other surfaces. Step 2 — after applying the pale color, glaze with the light Conte sanguine and add warm red. Notice where I started to add gold ochre in the forehead area to show you, again, how this color (over red . . .) gives a lustrous flesh tone. Continue with darks, greens, clothing, accessories . . . use black sparingly.

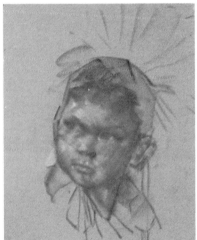

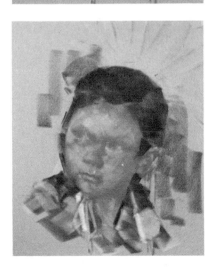

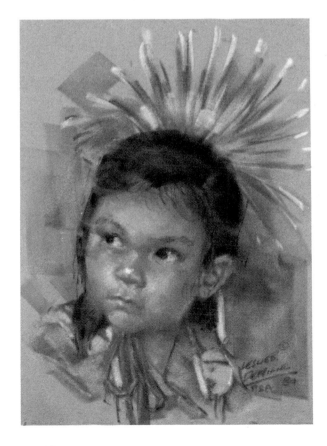

41

SHADOWS— SEPIA (Velour)

This is a portrait study, on a tanned surface, using just two colors—Conte crayon (warm sanguine) and white pastel. This is where I prefer the velour paper over others because I can put in crisp, dark accents along with soft, clean strokes that remain as they are. I have done literally thousands of portraits in this style, they are very pleasing because of their freshness and simplicity.

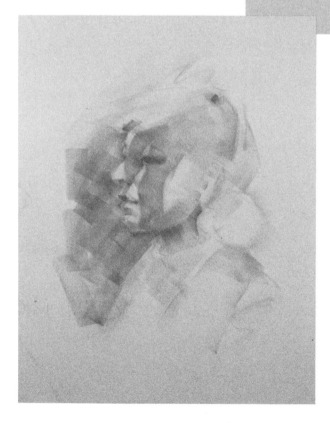

Using the flat edge of the Conte and pastel sticks, you can create these forms and strokes, as I have shown you on the beginning pages of this book (pages 6 & 7). Remember to start very softly with the Conte and build up more when you are sure of where the strokes will be. There is no erasing or covering up with other colors in this method (except in a very limited way with white).

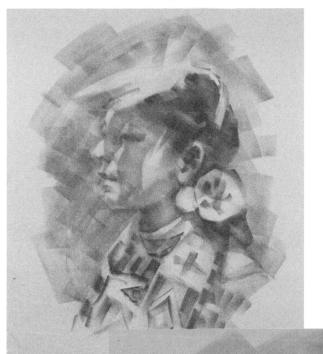

Don't be intimidated, just be sure to be extremely soft with the touch in the first stages. Complete with the darks, using more pressure and/or crisp strokes. Then, very softly, add white, increasing the pressure when you are sure that you want a strong light. I also wanted to show the effects of the play of light and shadow on the planes of the face, and how important it is to remember where the light is coming from, and to show your values accordingly.

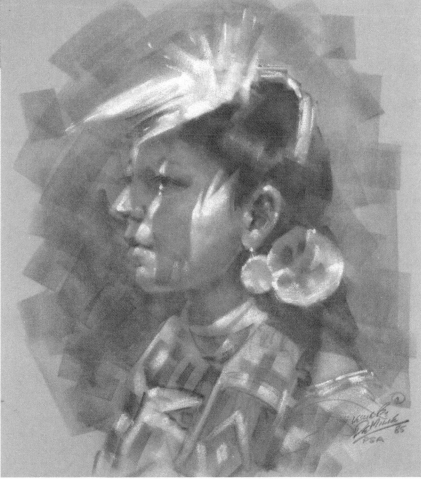

BACK NUDE (Velour)

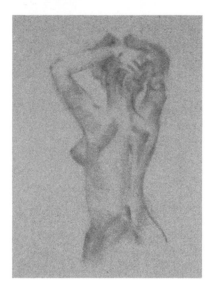

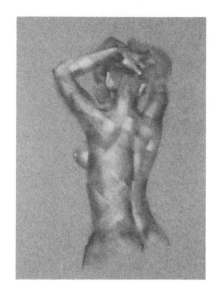

This is a small nude study that is rather simplistic in rendering. I almost always use a live model for doing figure work such as this, but this particular one is from a photo that I had taken of a model from a previous painting session. I am reluctant to suggest that you work from photographs. The only way you can really 'see', and interpret color, values, and form correctly, is by doing whatever you are doing, from life. Only after working extensively in this manner, can you hope to be able to work and interpret from photographs, so that your finished pieces do not look like they are done from photos. It is depressing to see a would-be artist's work that is obviously a copy of a photograph, especially when the artist is touted as being good, when it is obvious that they have never studied or worked from life.

Step 1 shows the initial Conte drawing, soft and interpretive. In Step 2, darker Conte sanguine and some lights. In Step 3, warm reds, ochres and green tones. Keep the line of the spine in the correct position. Keep the head and hair (in this particular one) very suggestive. Focus on the area of her shoulder, where the light is striking, by using the highest lights, and the sharpest contrasts. Make use of the cool tones on the flesh to give more natural tones and color to the body. There is nothing more beautiful than the human body, so make sure the tones, angles and accents of form are correct, not distorted or ugly. In the dark flesh, I sometimes use a dark sanguine Conte over a blue-grey or green. See the rich deep tones in this figure. The off-white background was added to give an over-all sparkle. Also, note the highlights on the shoulder, neck and bits of hair. Even the touch on the lower spine helps.

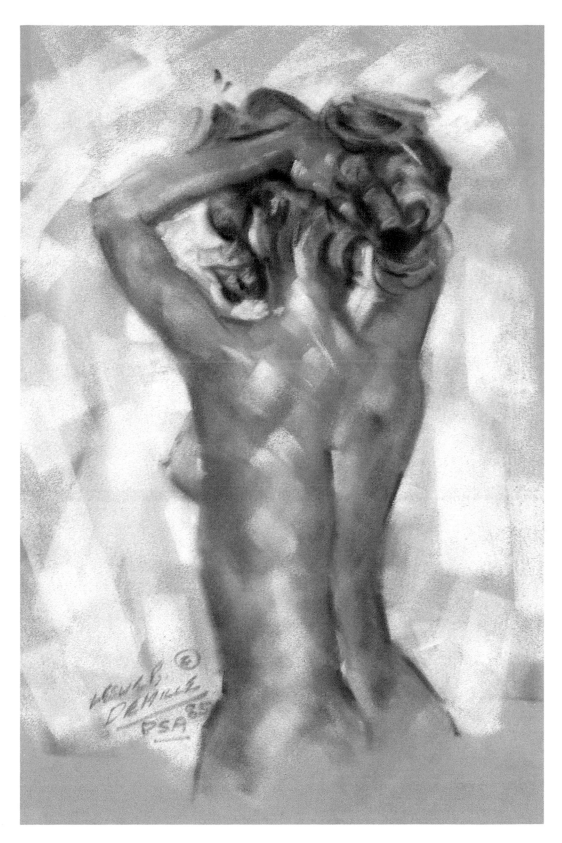

45

SULTRY II (Velour)

I can't think of a title to better describe this girl. I did another painting of her in a different pose and sold it to a client in Denver. I trust he will forgive me for using the same title! Start lightly with the dark areas, (see page 42) until you establish your drawing enough to add stronger detail. With a pale yellow ochre (Step 2), lay in highlights and other lights with simplicity. Brightest lights first on forehead and nose, then cheeks, chin and neck with progressively less tones. Keep in mind the source of light from above, right.

Add light Conte sanguine, and plenty of warm red for the rich flesh tones. Start with more red than you feel you need, otherwise you fall short of flesh color when you add the subsequent colors. In Step 3 apply gold ochre over the red, (see the glow of the flesh tones). Add dark blue-grey in the shadows, and green tones in areas of flesh where turning, and in side planes . . .

. . . Use blue and other colors in her hair, but keep it predominately blue to indicate black hair. Start T-shirt with white and add medium blue-grey in the

Here is a detailed painting of the eye. Notice the emphasis on the lights and the extra amount of red. Use black sparingly, inside the eye for extra depth, and for the pupil. Notice the red in the corner and around the folds of the lids.

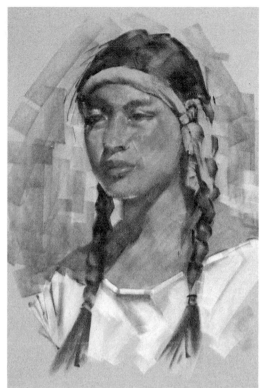

shadows. Use warm and cool greens and a touch of blue in the background, not necessarily abstract but loose.

Here, the green and pink tones are easier to see, and the depth up under the lid shows the lid protruding over the eyeball. The light coming from above, right, shows a slight translucency on the left side of the iris. Notice the position of the light on the pupil!

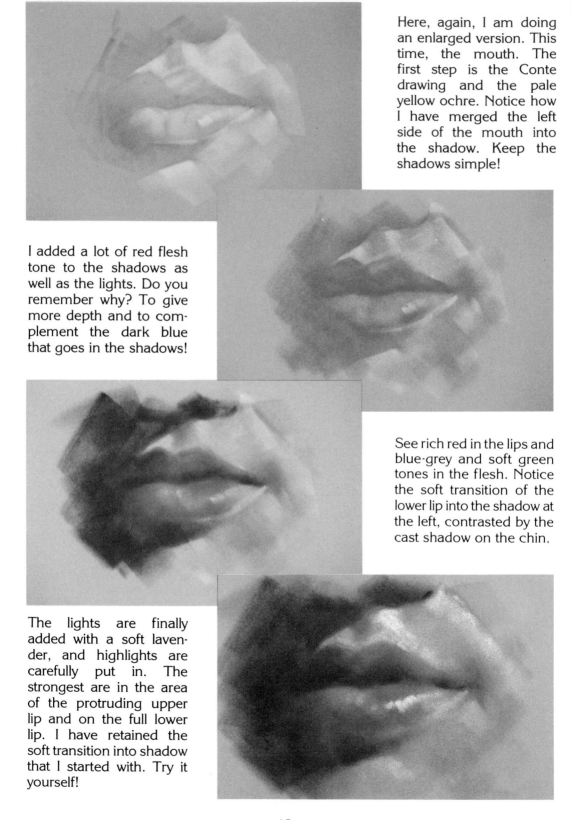

Here, again, I am doing an enlarged version. This time, the mouth. The first step is the Conte drawing and the pale yellow ochre. Notice how I have merged the left side of the mouth into the shadow. Keep the shadows simple!

I added a lot of red flesh tone to the shadows as well as the lights. Do you remember why? To give more depth and to complement the dark blue that goes in the shadows!

See rich red in the lips and blue-grey and soft green tones in the flesh. Notice the soft transition of the lower lip into the shadow at the left, contrasted by the cast shadow on the chin.

The lights are finally added with a soft lavender, and highlights are carefully put in. The strongest are in the area of the protruding upper lip and on the full lower lip. I have retained the soft transition into shadow that I started with. Try it yourself!

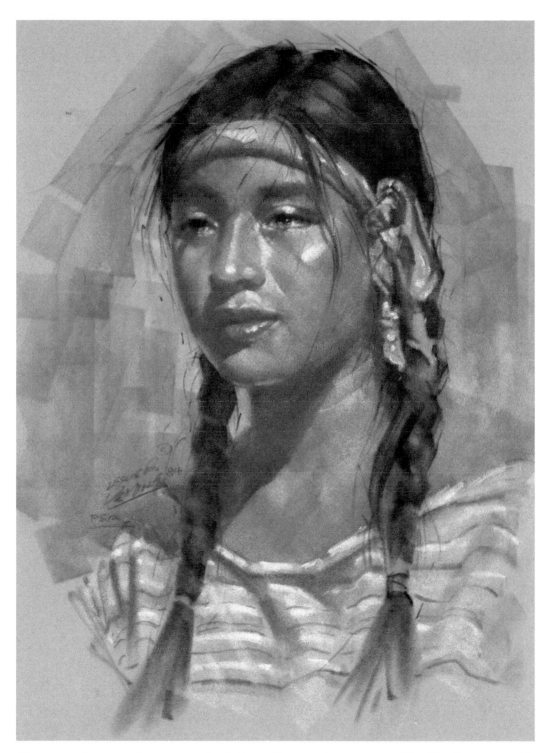

Use enough tone to have room for lights without going to pure white. Do the same with darks, without going to pure black. Spray with workable fixative, this deepens the tones, allowing addition of lighter and cleaner lights. Finish highlights with a cool tone, accent blacks in the hair, and add just an indication of stripes for an artistic look.

BIRDS (Velour)

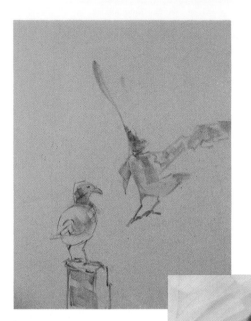

After sketching in the birds loosely and putting in the post for one bird to sit on, put in blue background for the water: deeper at the bottom, to throw out whites of the birds, and light at the top to show the brighter sky. Make the post round, not rectangular. Add dark grey-blue shadows on the birds. Use medium blue for lighter tones, the lights of black areas, and shadows in the whites. The one color serves for all. Add gold ochre tones to the beak, tail, legs, and feet . . . Put a blush of ochre tones through the greys so they're not too cold in color. Also add some reddish tones so it will not appear as just "dirty" grey.

When I added the darker tones to the birds, the value was too close to the background. I had to either darken the background, lighten the birds, or vice-versa. I decided to DARKEN the birds and LIGHTEN the background by pulling down lighter blue from the sky area into the darker blue. I increased the dark tones on the birds to get the darkest value possible. This makes the other values lighter, so be sure to compare your values, lights and darks. As long as there is some color all over, even on white-looking areas, I can still add white and pale yellows to get the added contrast I need in the whites.

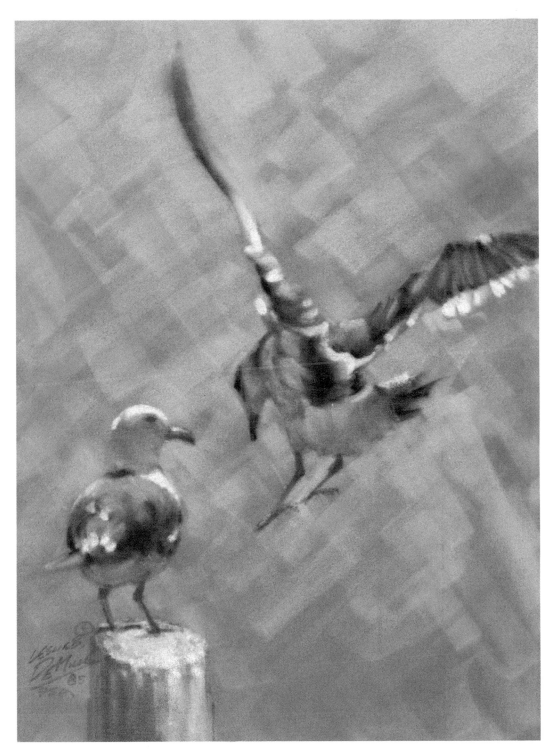

Look to your lower lights for form. Bright lights are an added, extra bonus. I added white to the bird on the post before I did the one in flight. See how it is 'sculpted' and stands out? Also, I have taken away the scratchy background, it is easier to look at and less confusing.

COCKER (Velour)

Animals are always great favorites. This one, in particular, is for me since it is our "Amber". Although this is a different painting of her, you may recognize her from my Foster book #184 *How To Draw Cats and Kittens* where I couldn't resist showing her off to all the cat lovers. I will explain

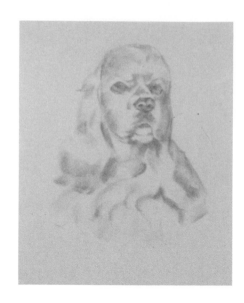

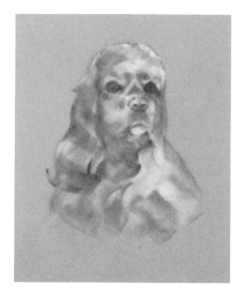

the main concern of showing the look of the fur while retaining the form of the dog. Often this seems to be a major problem. It can be thought of in the same way as doing the hair on the study of the head on page 40.

Most artists will at one time or another, want or need to paint their pet or one of a friend. Hopefully, this will make it easier for you. You can see where I put in a lot of sepia tones (with Conte warm sanguine), and after using the pale ochre for the light fur, some cool greens.

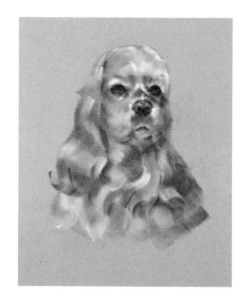

52

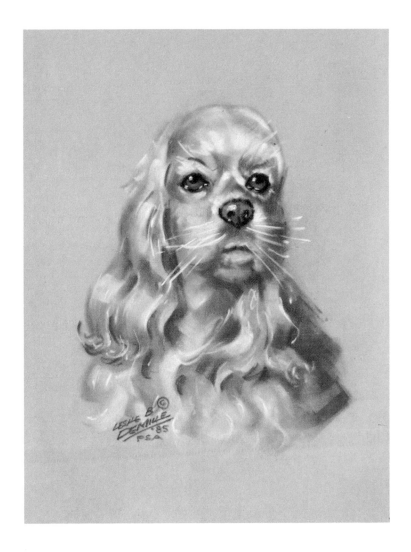

Remember, one of the things that is helpful when doing fur, hair, details, etc., is to simplify the shadows as much as possible. It makes sense when you have a lot of 'activity' going on all over, you don't have any areas of rest, which you need. What better place for relief than in the shadows? With this in mind, after you put in your darks and other colors, you can accent and put 'activity' in the lights, but remember, you only need to suggest SOME detail. Don't pick it to death.

HAIR TIES (Velour)

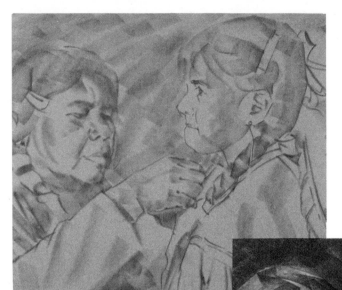

The expression on this little girl's face, as she gets her ribbons re-tied by her mother, is the key to this painting. Her face is the most prominent feature. The mother's eyes and hand bring your eye to the girl's face. Although the feather behind the girl's head looks like it is going out of the painting, it still leans in, towards her face. This painting required more careful drawing to start, after loosely adding some background area strokes to get the general composition.

Using dark blue-grey in the background, with it's pattern and the mother's braids leading to the girl, I established more of the drawing by using negative space (the girl's profile . . .). I then added all areas of general color: reds, blues, etc., all over; and light flesh tones on both faces and hands (not as light on the mother's flesh). Next, I added lots of red, gold ochre and green to these flesh tones.
Gold ochre over the bright red changes it from raw red to varying, ochre-ish flesh color. (Keep the girl's facial tones cleaner and lighter than the mother's.)

54

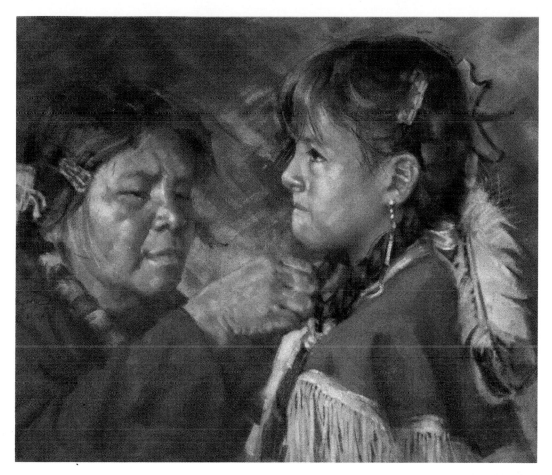

Keep it all progressing at the same stage so you can leave it at any time and still have it look presentable. Through Step 3, I have a very severe, stiff mouth and chin on the girl. I wanted to show this disgruntled look on her face, opposed to the calm, passive expression on her mother.

When I applied the lights to the final stage, I softened the disgruntled look on the girl by rounding the forms under the eye and on the cheek; and by turning the mouth up very slightly. I have often quoted the phrase that "A portrait is a painting of someone with something wrong with the mouth". The expressions around the mouth area will change with only the slightest thought of happiness, sorrow, anger Try it in front of a mirror. Just the thought of something can change your whole expression. I believe it starts in and around the eyes, but then the mouth changes, which of course, changes the rest of the facial muscles depending on the severity of the expression. I didn't intend to deviate so much on the mouth, but it seemed like a good lesson at this time. Remember, the mouth takes a large area, not only the lips, just as the eyes are expressed by the whole socket area, not just the eyeball. In the finished painting, you can see the extra depth in the mother's flesh tones. Notice how the hand is subdued in value so it doesn't interfere with the facial expressions. See the different colors in the background that tie it all together. The strong blues in the hair are still showing through the black that was added to give the appearance of black hair with glints of color. The bit of white in the mother's hair suggests age. I also left the mother's face with a 'chunkier' application to contrast with the girl's smooth complexion.

ZUNI—SEPIA (Velour)

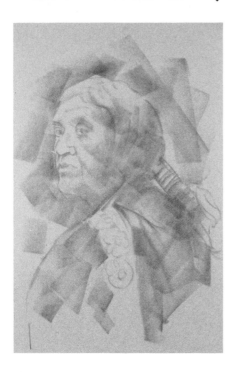

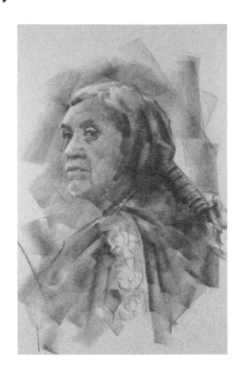

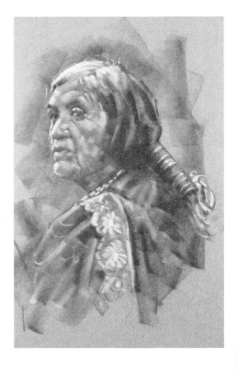

This contains the same type of information as "Shadows" (page 42). The main difference is that I used two different sepia Conte colors on this one. It starts with the use of the lighter, warmer sanguine color. Complete your drawing with this color. Add the whites, noting the strong highlights along the side of the face where the light is coming from. This means the shadow side (most of the features) are in a very subdued light and therefore have very little white added. (Notice the SUBTLE use of white in these areas.) Then I added extra contrast (dark sanguine Conte), which gives even more dimension and depth to the finished work. Note the lesser use of this dark sanguine in flesh areas, used mostly in the eyes. The drawing is more essential in a close profile view like this one, so be very aware and careful of your drawing and proportions. If you think of the head as flat planes, it should be easier when placing the features on the correct plane with the right perspective.

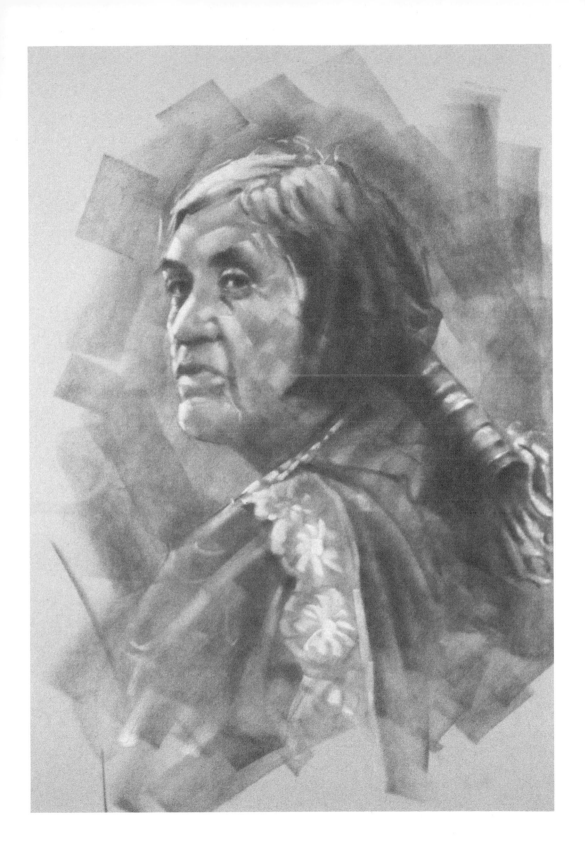

THE CHASE (Velour)

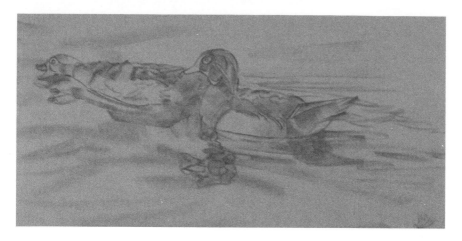

Yes! The chase is always on! With humans it is the women who look beautiful, colorful and attractive to the men. In this case, the male duck has the colorful plumage to attract females (though it seems the male still does the chasing). Aside from the two ducks, this is an excellent water study.

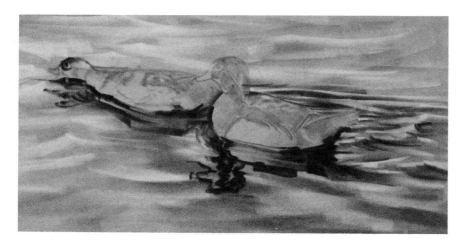

There are four shades of blue used for the water. Start with a medium blue, then go darker and lighter. After applying the blues for the water, put in the body tone of the ducks. Use brighter and richer colors for the one in the foreground, not only because he is in the foreground but, also, as I said above, because the male is more colorful.

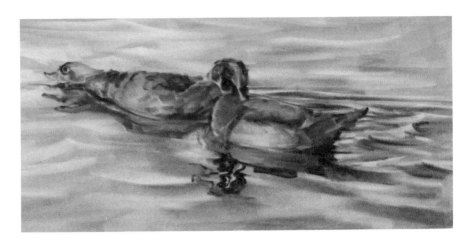

On the female use browns, ochres, and subdued tones. Notice the darkening for the shadows and to show the volume, even though there is a pattern. This helps to show the roundness. You must retain this volume and roundness on the ducks' bodies.

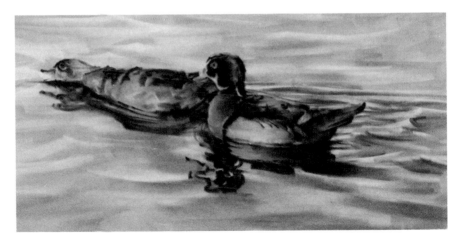

Add ochre and reddish tones to the water so that it is not such an isolated blue color. (Also, add water-blue into areas of the ducks to tie things together.) Add black, varying the pressure to get intense black, or blush over to get a toning effect.

See page 60 for the final painting.

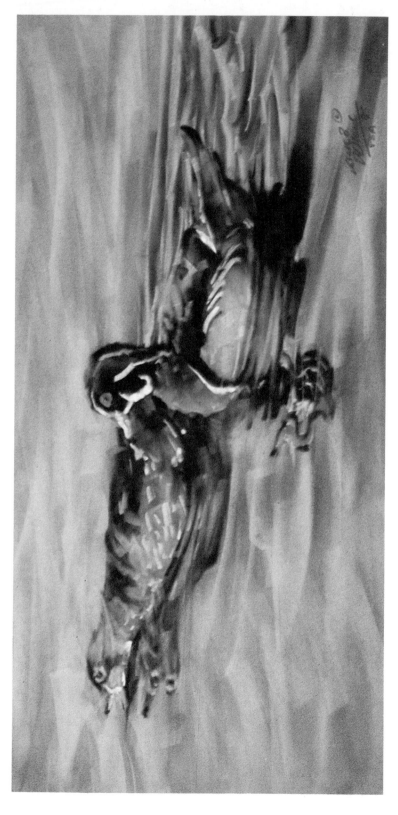

Soften the look of the ducks, especially the farthest one. Pull some blues from the water into the ducks to give a more subdued, together look. Take note that the colors in the water for the reflections of the ducks are subdued and greyed a little bit. The waves and ripples in the water, although they might appear to be random strokes, actually have a definite pattern and swell. Squint your eyes to see how the water flows when the action increases as you get closer to the movement of the ducks.

60

HANDS—YOUNG & OLD (Canson)

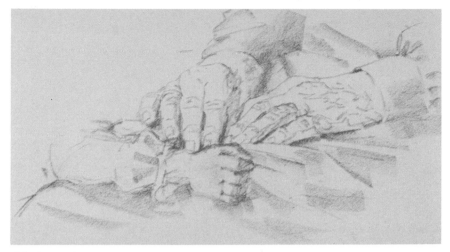

I believe that hands are one of the most difficult subjects to master. These elderly hands were inspired by the portrait that appears on page 64. I added the child's hand to show the contrast between young and old. In the first step, I blocked the hands and the fingers into planes to keep them from looking like bananas. Notice the child's hand where I shaded the side of the fingers that are in shadow. I used the same treatment on the older hand, showing a definite front and side plane to each finger. Step 2 shows an intensifying of these same planes, using Conte,with the suggestion of a warm tone on the hands. Then I added color all over; red on the dress, dark blue in the shadowing of the dress, dark and medium blues in the background, and a pink tone on the little girl's arm that carries over into the background. Notice that I have not, yet, smudged or pulled the colors together. In Step 3, on the following page there is no addition of color. The only difference is that I have used my finger to pull areas together, allowing the tones to run into each other.

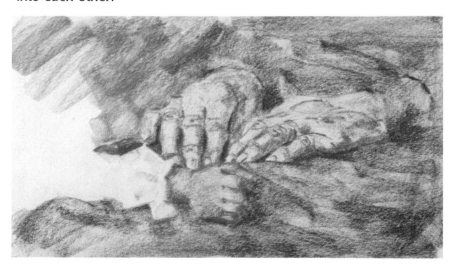

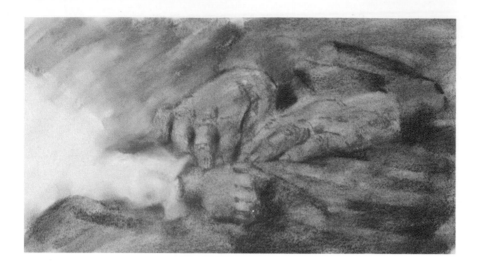

In Step 4, I have added the warm reds, ochres, greens and blues to the hands. The older hands are done by using darker values with cooler tones and more contrast. See the extra amount of green and ochre that I added to the older hand, while retaining a smooth, fresh and pinker look to the child's hand. I added more red to the dress and more pink to the child's arm, extending into the background. The wrinkles are FORMS rather than lines as described on pages 38 and 39. Again, I want you to observe the amount of color on the flesh tones where they come out of the shadows, especially where the wrinkles and creases of the fingers and knuckles are. You will do well to observe that most, if not all, of our body joints have an extra warmth around them. Think about the elbows, knees, feet, and hands. Have you noticed? Take a look! If you squint you will be able to see better. Also, while you are at it, look at your face and notice the 'warm band' that extends from the ear, cheek, nose, other cheek and around to the other ear.

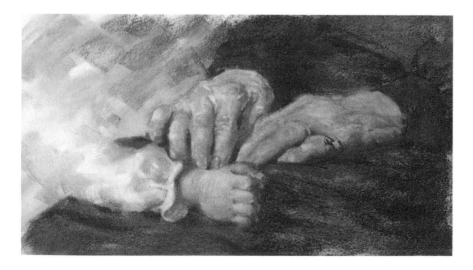

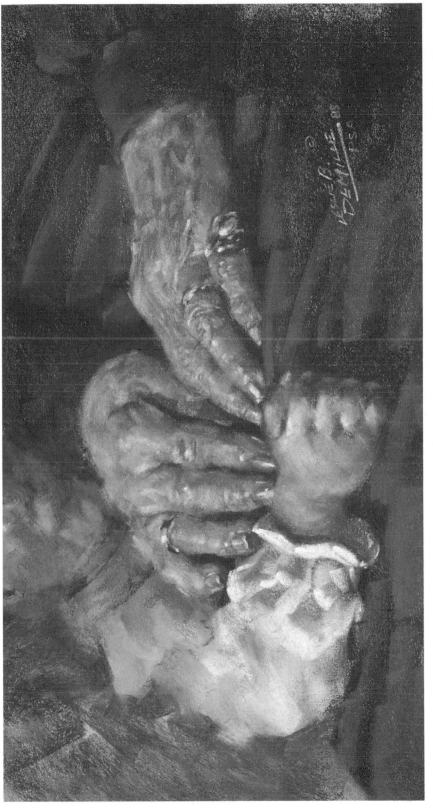

Using light tones to model the forms of the wrinkles, instead of dark tones to 'gouge' them, I finished with the highlights. Notice how I pulled together some of the fingers. This gives them the feeling of merging, not isolation. See the softness of the girl's hand, and the nice reflected green in the shadow. The child's arm coming onto the lap looks too long and out of place in the steps. You can see what I did to change this problem in the finished painting above. Make it an even more appealing painting by suggesting the child's features in the background. PLEASE let me know how you enjoyed this book and if I was helpful to you.

SCOTTISH MEMORIES (Canson)

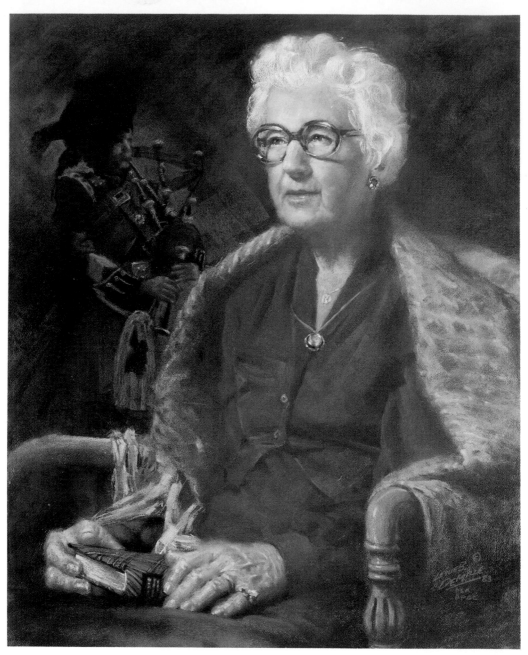

This is a portrait of my mother-in-law, Mrs. John C. Don, who celebrated her 96th birthday on July 18, 1985, and is still in good health. I must say that with her very smooth complexion and LACK of wrinkles, she certainly holds her age well; although, her white hair and her hands may tend to give her away. The added Scottish piper in the background was inspired by her Scottish heritage. She loves to read from the book of Robbie Burns that is shown in her lap. The mohair shawl lends an added softness to this dignified figure.